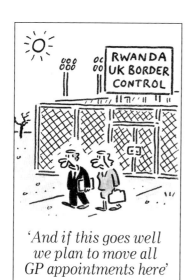

'And if this goes well
we plan to move all
GP appointments here'

The Daily Telegraph

THE BEST OF

MATT

2022

SEVEN DIALS

An Orion Paperback

First published in Great Britain in 2022 by Seven Dials
A division of the Orion Publishing Group Ltd
Carmelite House
50 Victoria Embankment
London
EC4Y 0DZ

An Hachette UK Company

10 9 8 7 6 5 4 3 2 1

A CIP catalogue record for this book is available from the British Library.

ISBN mmp: 978 1 4091 9152 0
ISBN ebook: 978 1 4091 9153 7

Printed in Italy by Elcograf S.p.A

The Orion Publishing Group's policy is to use papers that are natural,
renewable and recyclable products and made from wood grown in
sustainable forests. The logging and manufacturing processes are expected
to conform to the environmental regulations of the country of origin.

www.orionbooks.co.uk

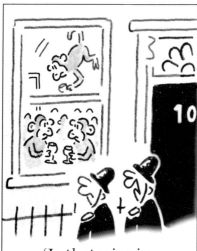

'Is that wise in the middle of a monkeypox pandemic?'

THE BEST OF

MATT

2022

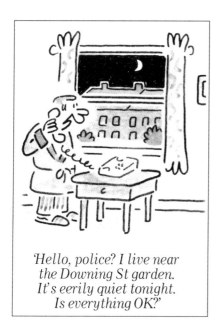

'Hello, police? I live near the Downing St garden. It's eerily quiet tonight. Is everything OK?'

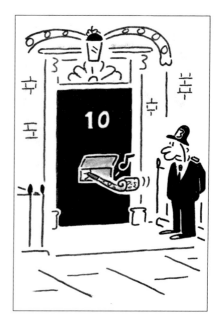

Partygate

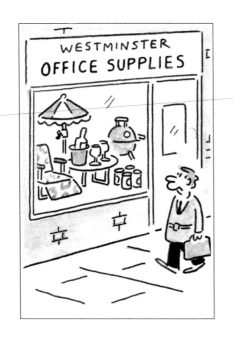

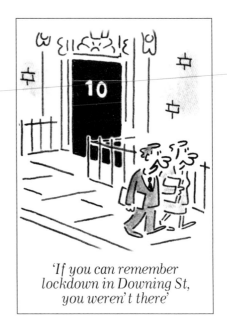

'If you can remember
lockdown in Downing St,
you weren't there'

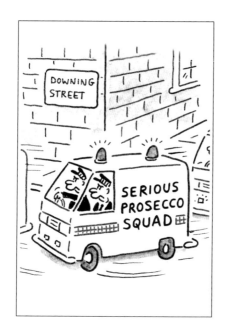

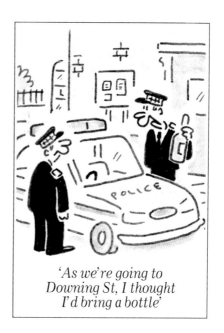

'As we're going to
Downing St, I thought
I'd bring a bottle'

Partygate

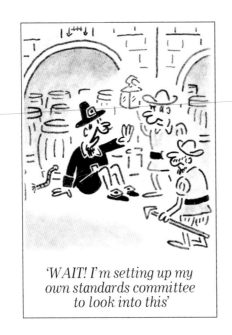

'WAIT! I'm setting up my own standards committee to look into this'

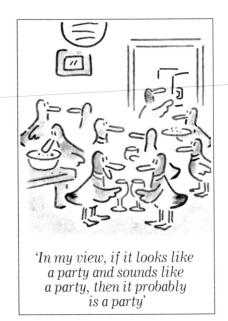

'In my view, if it looks like a party and sounds like a party, then it probably is a party'

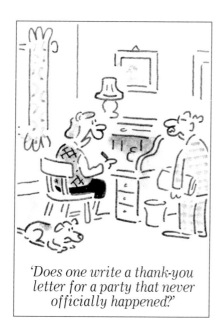

'Does one write a thank-you letter for a party that never officially happened?'

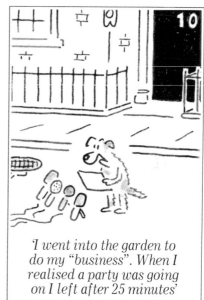

'I went into the garden to do my "business". When I realised a party was going on I left after 25 minutes'

Partygate

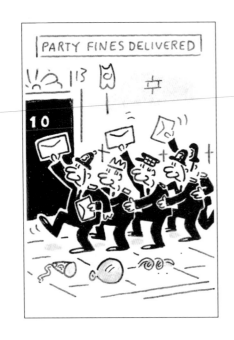

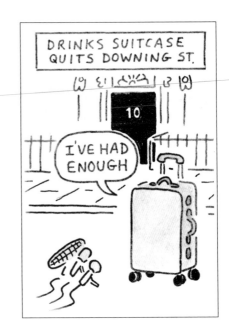

'People should get partygate into perspective. It's not as if Boris ran through a field of wheat'

Theresa May's comment lives on

'We're trusting you to be responsible while we're away. Don't invite the Prime Minister and his colleagues round'

'Yes, I've eaten all the
Easter eggs, but there's a
war going on and we should
focus on the bigger picture'

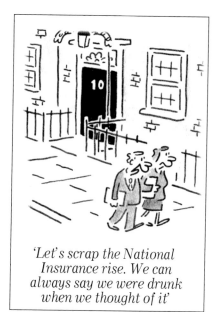

'Let's scrap the National
Insurance rise. We can
always say we were drunk
when we thought of it'

A Covid Christmas

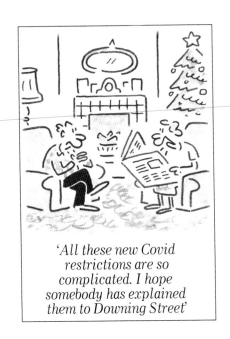

'All these new Covid restrictions are so complicated. I hope somebody has explained them to Downing Street'

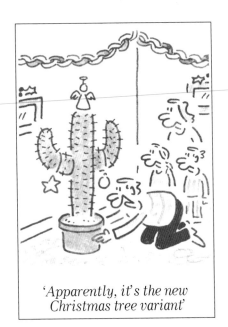

'Apparently, it's the new Christmas tree variant'

'The booster jabs
were a surprise'

'It's the latest Advent
calendar. You close a
window every day till
Christmas is cancelled'

A Covid Christmas

'The Sage Christmas party was wild! After the fifth lateral flow test I lost count'

'It's our Christmas tradition. They do a beautiful midnight booster jab by candlelight'

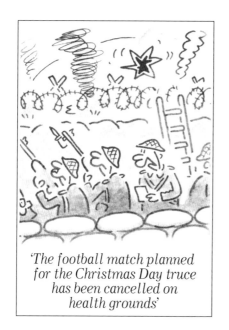

'The football match planned
for the Christmas Day truce
has been cancelled on
health grounds'

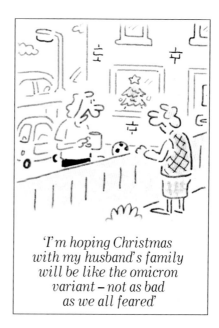

'I'm hoping Christmas
with my husband's family
will be like the omicron
variant – not as bad
as we all feared'

A Covid Christmas

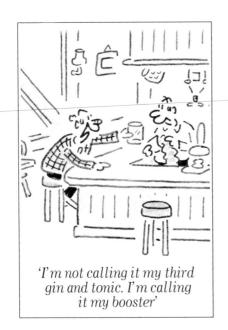

'I'm not calling it my third gin and tonic. I'm calling it my booster'

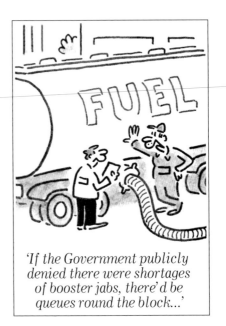

'If the Government publicly denied there were shortages of booster jabs, there'd be queues round the block...'

Fuel shortages

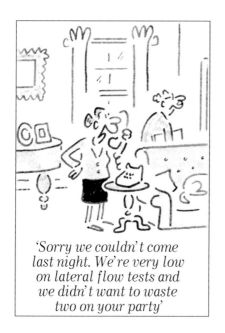

'Sorry we couldn't come last night. We're very low on lateral flow tests and we didn't want to waste two on your party'

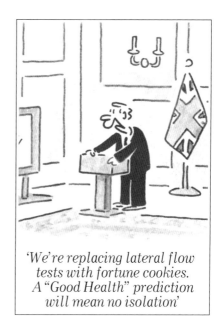

'We're replacing lateral flow tests with fortune cookies. A "Good Health" prediction will mean no isolation'

Working From Home

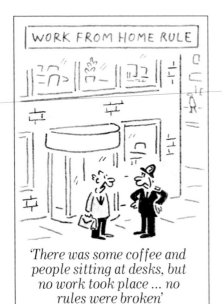

'There was some coffee and people sitting at desks, but no work took place ... no rules were broken'

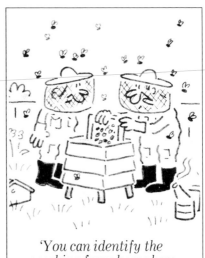

'You can identify the working-from-home bees because they're the ones wearing dressing gowns'

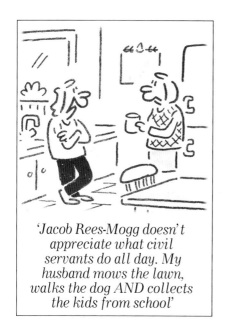

'Jacob Rees-Mogg doesn't appreciate what civil servants do all day. My husband mows the lawn, walks the dog AND collects the kids from school'

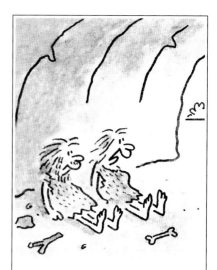

'Your hunter-gathering from home isn't working so well'

Working From Home

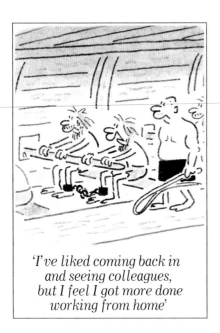

'I've liked coming back in and seeing colleagues, but I feel I got more done working from home'

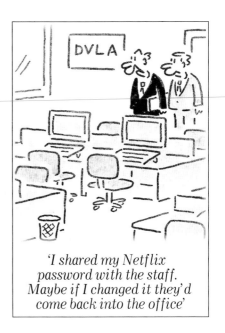

'I shared my Netflix password with the staff. Maybe if I changed it they'd come back into the office'

Rees-Mogg critical of civil servants WFH

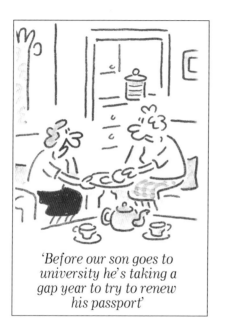

'Before our son goes to
university he's taking a
gap year to try to renew
his passport'

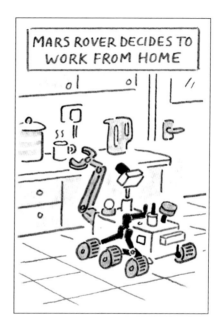

MARS ROVER DECIDES TO
WORK FROM HOME

Cost of Living Crisis

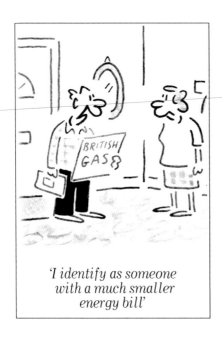

'I identify as someone with a much smaller energy bill'

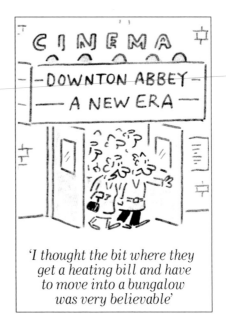

'I thought the bit where they get a heating bill and have to move into a bungalow was very believable'

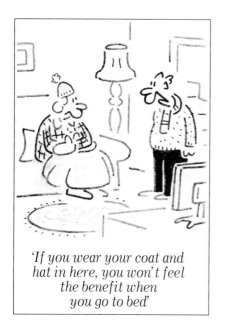

'If you wear your coat and hat in here, you won't feel the benefit when you go to bed'

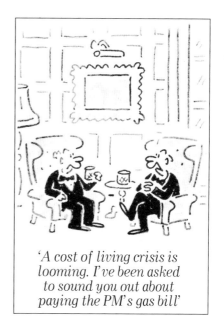

'A cost of living crisis is looming. I've been asked to sound you out about paying the PM's gas bill'

Cost of Living Crisis

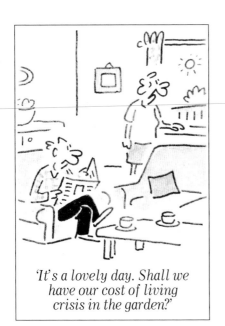

'It's a lovely day. Shall we have our cost of living crisis in the garden?'

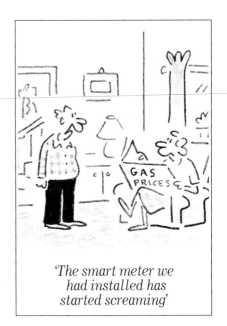

'The smart meter we had installed has started screaming'

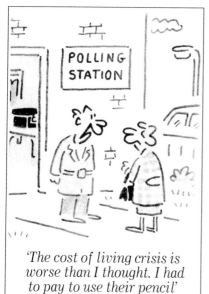

'The cost of living crisis is worse than I thought. I had to pay to use their pencil'

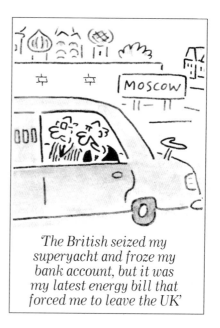

'The British seized my superyacht and froze my bank account, but it was my latest energy bill that forced me to leave the UK'

Cost of Living Crisis

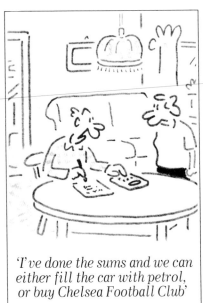

'I've done the sums and we can either fill the car with petrol, or buy Chelsea Football Club'

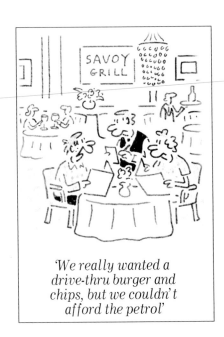

'We really wanted a drive-thru burger and chips, but we couldn't afford the petrol'

Abramovitch sells Chelsea

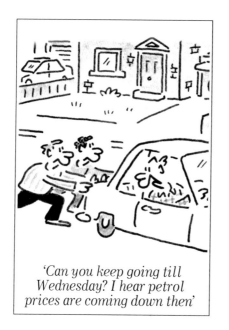

'Can you keep going till Wednesday? I hear petrol prices are coming down then'

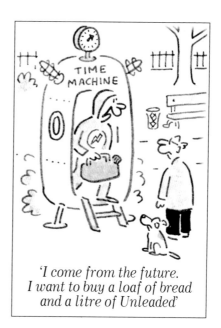

'I come from the future. I want to buy a loaf of bread and a litre of Unleaded'

Cost of Living Crisis

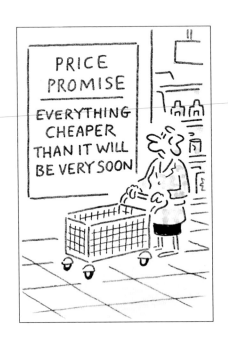

'Food prices are soaring,
but I managed to catch
these eggs before they hit
the statue of Lady Thatcher'

'We've been waiting ages for
our main course. I'm worried
it will have gone up in price
by the time it gets here'

'There's a change of plan. Now we're going to take from the rich, low paid and elderly'

'You listen to Rishi Sunak's speech while I go and siphon the petrol out of his car'

'Don't go mad with your three wishes. I'm not Rishi Sunak'

Chancellor asked to ease the burden

MPs' Second Jobs

'I Googled my own name
and apparently I'm an MP'

MPs DEBATE SECOND JOBS

'Could everyone keep quiet
for a moment, this is an
important work call'

'He's a brilliant working dog, but I worry it interferes with his job as an MP'

'I'm urging all MPs with two jobs to get a third, booster job, to see them through Christmas'

Tanker Driver Shortages

'If you can eat this sausage
sandwich and drink the
mug of tea, you've passed'

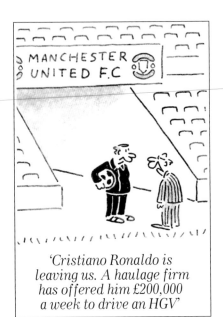

'Cristiano Ronaldo is
leaving us. A haulage firm
has offered him £200,000
a week to drive an HGV'

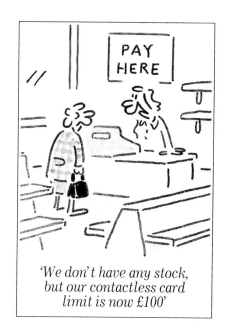

'We don't have any stock, but our contactless card limit is now £100'

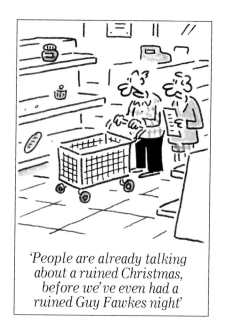

'People are already talking about a ruined Christmas, before we've even had a ruined Guy Fawkes night'

Tanker Driver Shortages

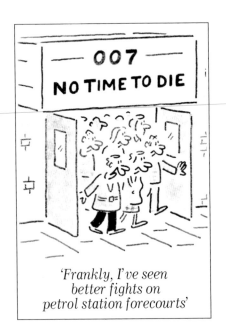

007
NO TIME TO DIE

'Frankly, I've seen better fights on petrol station forecourts'

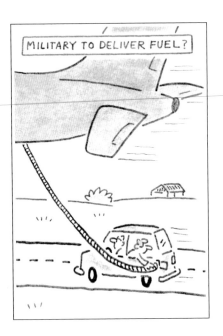

MILITARY TO DELIVER FUEL?

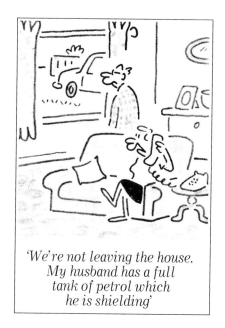

'We're not leaving the house. My husband has a full tank of petrol which he is shielding'

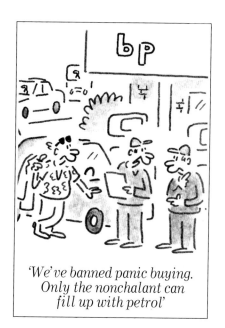

'We've banned panic buying. Only the nonchalant can fill up with petrol'

NHS

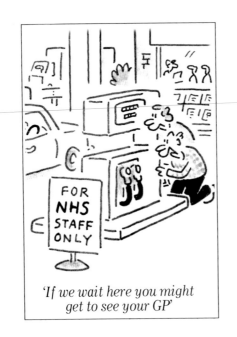

'If we wait here you might
get to see your GP'

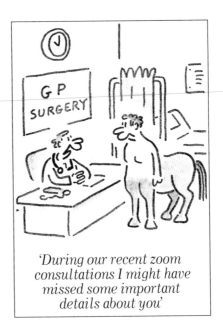

'During our recent zoom
consultations I might have
missed some important
details about you'

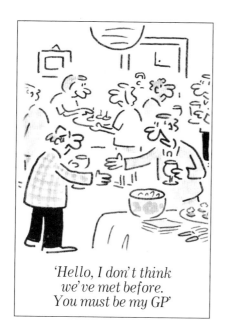

'Hello, I don't think
we've met before.
You must be my GP'

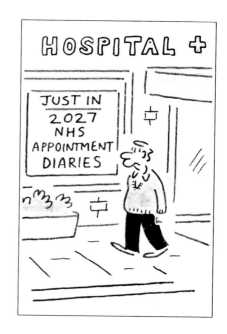

Energy

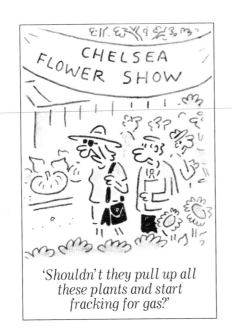

'Shouldn't they pull up all these plants and start fracking for gas?'

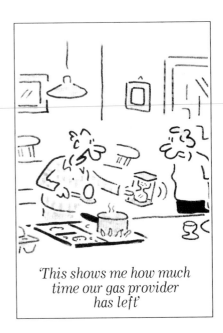

'This shows me how much time our gas provider has left'

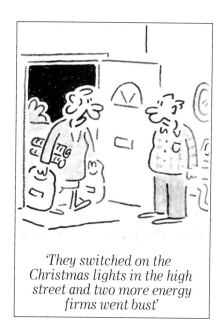

'They switched on the Christmas lights in the high street and two more energy firms went bust'

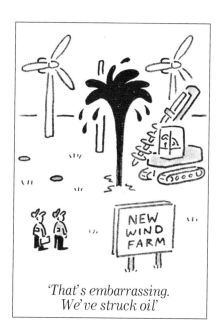

'That's embarrassing. We've struck oil'

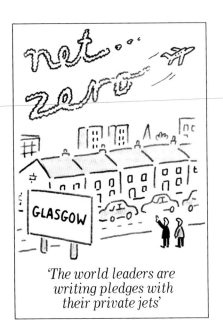

'The world leaders are writing pledges with their private jets'

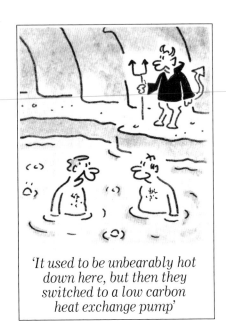

'It used to be unbearably hot down here, but then they switched to a low carbon heat exchange pump'

COP 26

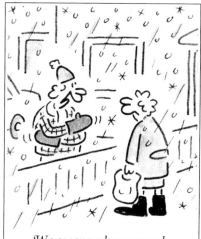

'We swapped our wood burning stove for solar panels. On sunny days we can have the electric fire on'

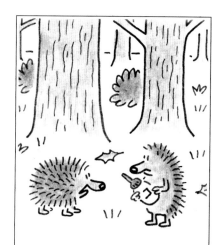

'I know you want to protest about climate change, but supergluing yourself to the M25 is a terrible idea'

Putin and Oligarchs

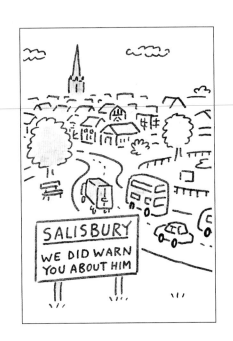

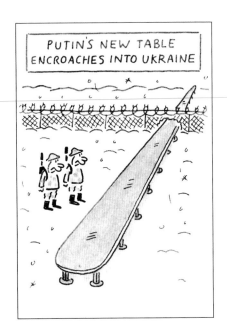

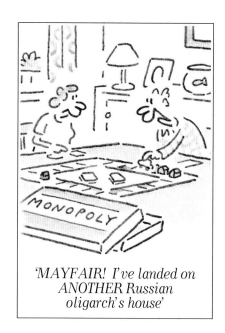

'MAYFAIR! I've landed on ANOTHER Russian oligarch's house'

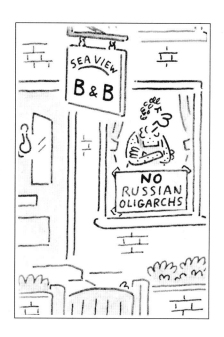

Law and Order

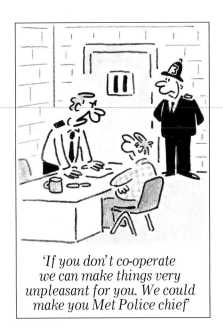

'If you don't co-operate
we can make things very
unpleasant for you. We could
make you Met Police chief'

Cressida Dick resigns

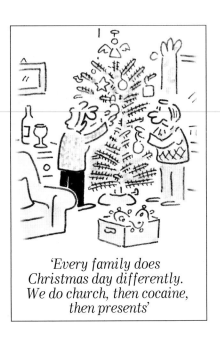

'Every family does
Christmas day differently.
We do church, then cocaine,
then presents'

Middle class drug-taking

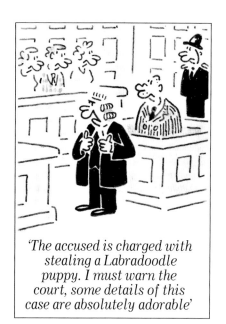

'The accused is charged with stealing a Labradoodle puppy. I must warn the court, some details of this case are absolutely adorable'

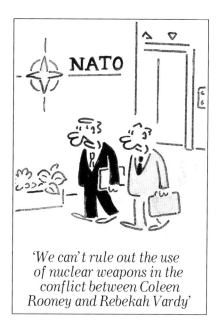

'We can't rule out the use of nuclear weapons in the conflict between Coleen Rooney and Rebekah Vardy'

Tractor Porn

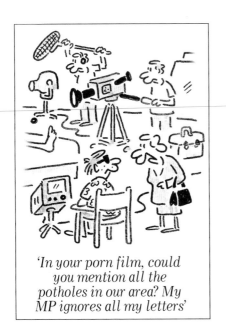

'In your porn film, could you mention all the potholes in our area? My MP ignores all my letters'

MPs under attack

'Who is Massey Ferguson
and why did you shout out
their name?'

'I searched for "flagellation"
and accidentally stumbled
upon our election results'

MPs under attack

'The next crossing is at 11.30. Have you ever captained a ferry before?'

'Don't tell people you're a P&O executive. Pretend you're a Russian oligarch'

P&O staff crisis

'Hello, Mum. I'm disowning
you with immediate effect.
It's to avoid the expense
of Mother's Day'

'For promoting staycations
in the UK, the contenders
are: P&O Ferries and the
Passport Office....'

The Royals

'Once upon a time a beautiful lady married a handsome prince. The rest is private. The end.'

POST OFFICE

'I've just heard the news about Prince Andrew. Will there be a commemorative 50p coin?'

'Next week will be one
huge work event for
the whole country'

'I've made the Jubilee
Trifle even more royal
by adding a layer
of Coronation Chicken'

End of Boris

'When they start saying
Boris will serve a third term,
they've had enough to drink'

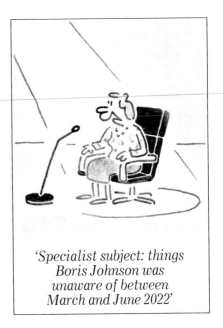

'Specialist subject: things
Boris Johnson was
unaware of between
March and June 2022'

Deputy Whip suspended

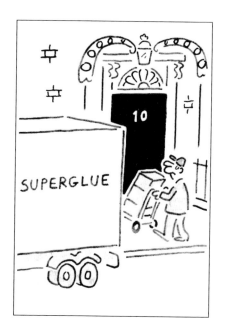

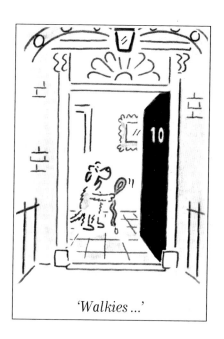

'*Walkies ...*'

Boris clings on

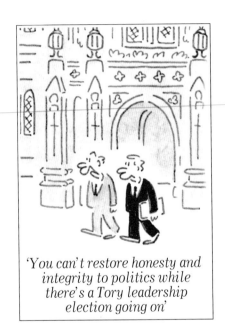

'You can't restore honesty and integrity to politics while there's a Tory leadership election going on'

'Doctors warn that too much sun on the top of the head can cause people to stand for the leadership of the Tory party'

11 Leadership contenders

'I'm hoping to come second and then I'll start plotting against the winner'

'The Tory party is about to make a huge mistake. I just don't know which one'

Flight Chaos

'Had any nice holiday plans ruined recently?'

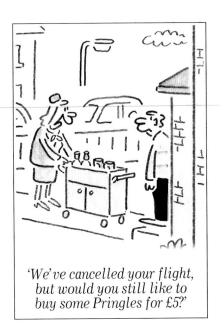

'We've cancelled your flight, but would you still like to buy some Pringles for £5?'

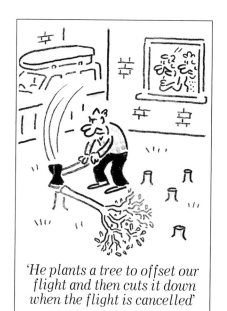

'He plants a tree to offset our flight and then cuts it down when the flight is cancelled'

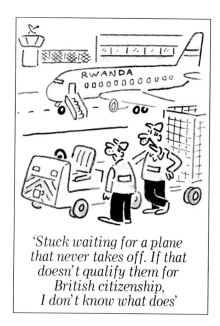

'Stuck waiting for a plane that never takes off. If that doesn't qualify them for British citizenship, I don't know what does'

Asylum plan

Rail Strikes

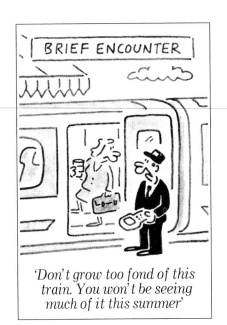

'Don't grow too fond of this train. You won't be seeing much of it this summer'

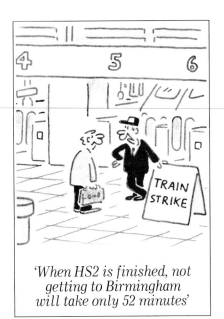

'When HS2 is finished, not getting to Birmingham will take only 52 minutes'

'This property is an absolute bargain. It's close to a train station, so it's cut off from everywhere'

'Like everyone else in the UK, we're going on strike. Fetch your own damn ball'

'And now it's time for
the weather forecast...'

'The Met Office has issued an Amber warning, meaning there's a danger someone will tell you how little sleep they had last night'

'Gas prices are so high I'm going to fry myself an egg on the pavement'

Heatwave

'It's Mediterranean! If we'd
only lost our own luggage
we could be on holiday'

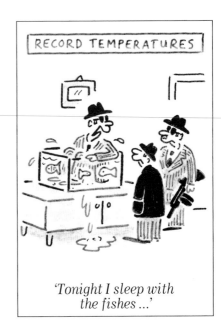

'Tonight I sleep with
the fishes ...'

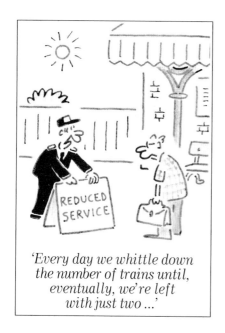

'Every day we whittle down
the number of trains until,
eventually, we're left
with just two ...'

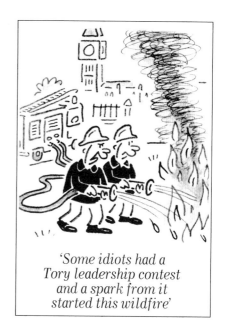

'Some idiots had a
Tory leadership contest
and a spark from it
started this wildfire'

Tory leadership

And finally...

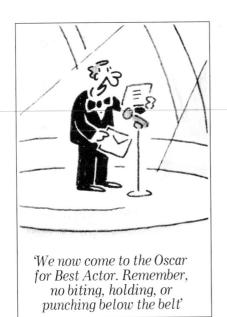

'We now come to the Oscar for Best Actor. Remember, no biting, holding, or punching below the belt'

Will Smith debacle

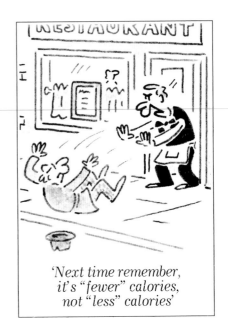

'Next time remember, it's "fewer" calories, not "less" calories'

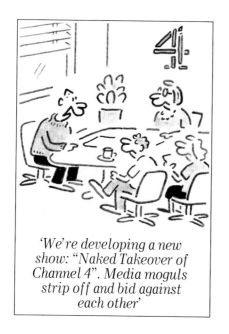

'We're developing a new show: "Naked Takeover of Channel 4". Media moguls strip off and bid against each other'

Channel 4 to be sold

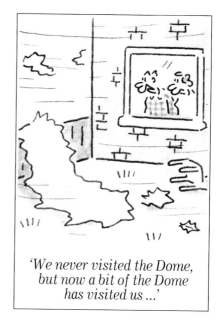

'We never visited the Dome, but now a bit of the Dome has visited us ...'

Storm Eunice

And finally...

And finally...

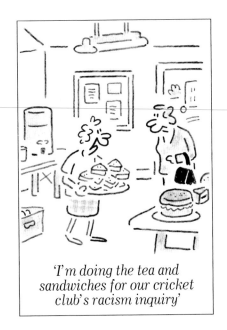

'I'm doing the tea and sandwiches for our cricket club's racism inquiry'

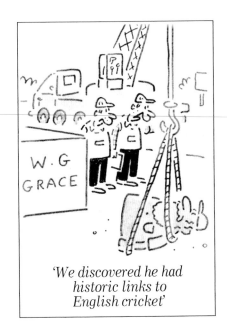

'We discovered he had historic links to English cricket'

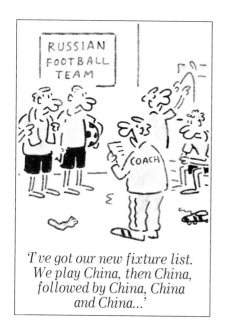

'I've got our new fixture list.
We play China, then China,
followed by China, China
and China...'

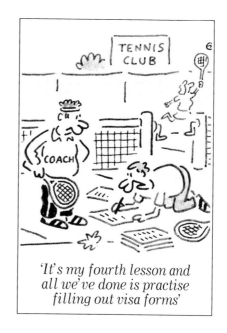

'It's my fourth lesson and
all we've done is practise
filling out visa forms'

Novak Djokovic's visa

And finally…

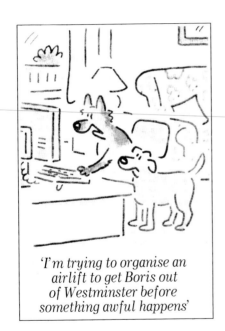

'I'm trying to organise an airlift to get Boris out of Westminster before something awful happens'

Animals rescued from Afghanistan

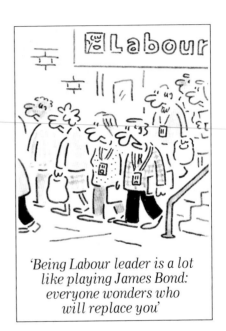

'Being Labour leader is a lot like playing James Bond: everyone wonders who will replace you'

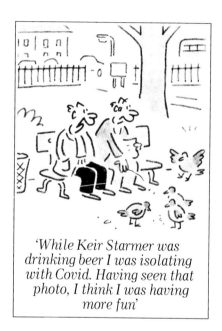

'While Keir Starmer was drinking beer I was isolating with Covid. Having seen that photo, I think I was having more fun'

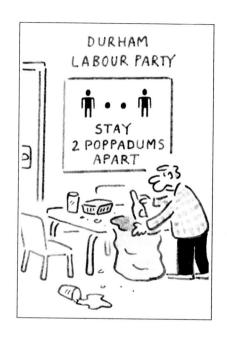

DURHAM LABOUR PARTY

STAY 2 POPPADUMS APART

Beergate

And finally…

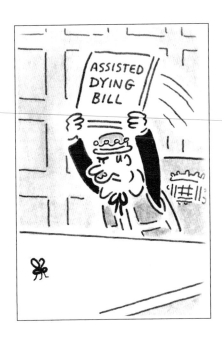

'I deliver presents to children
all over the world … well,
I don't go as far as Leeds'

HS2 route revised

'It's an onshore wind farm
now, but with rising
sea levels, it will soon
be offshore'

'If sea levels rise a couple
of metres, whole cities
could be affected by new
fishing disputes'

And finally...

'I might defect to the
Liberal Democrats.
The whole country needs a
good laugh at the moment'

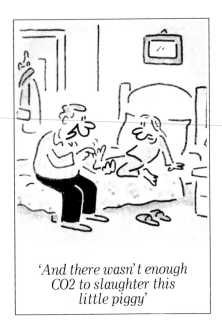

'And there wasn't enough
CO2 to slaughter this
little piggy'

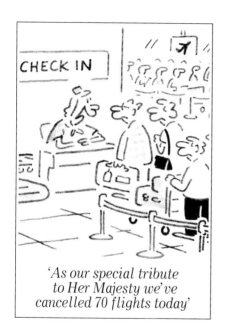

'*As our special tribute to Her Majesty we've cancelled 70 flights today*'

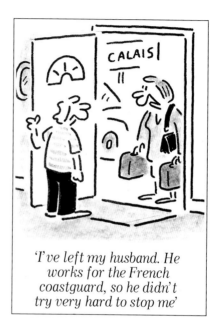

'*I've left my husband. He works for the French coastguard, so he didn't try very hard to stop me*'

And finally...

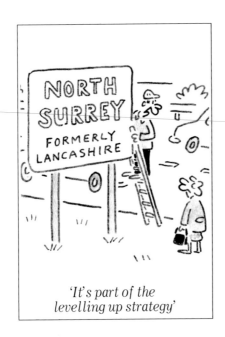

'It's part of the
levelling up strategy'

'Everyone in the street voted
to knock down your house'